D1541324

LOVE IS A LABRADOR

summersdale

LOVE IS A LABRADOR

An Hachette UK Company
www.hachette.co.uk

Summersdale Publishers Ltd
Part of Octopus Publishing Group Limited
Carmelite House
50 Victoria Embankment
LONDON
EC4Y 0DZ
UK

www.summersdale.com

Printed and bound in China

ISBN: 978-1-78685-982-2

Substantial discounts on bulk quantities of Summersdale books are available to corporations, professional associations and other organizations. For details contact general enquiries: telephone: +44 (0) 1243 771107 or email: enquiries@summersdale.com.

INTRODUCTION

Loyal, loving and absolutely full of life, Labradors are the perfect canine companion. Their wagging tails and puppy-dog eyes are quite simply irresistible. If you thought you couldn't squeeze any more Labrador love into your heart, think again! This book is about to showcase some of their most mischievous and marvellous moments, for us to share in the joy of this extraordinary breed.

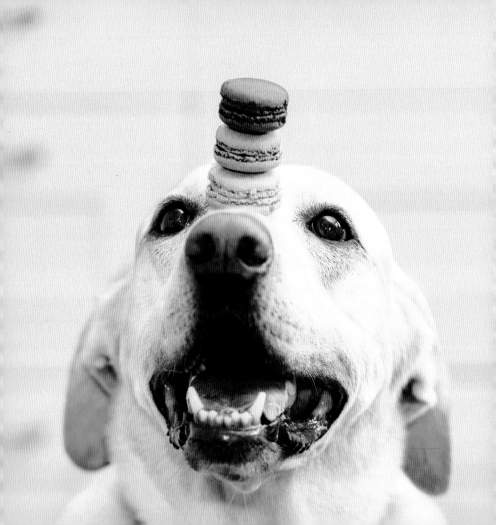

♥ AM I ♥

THE CLEVER BOY?

HAPPINESS IS
A WARM PUPPY.

Charles M. Schulz

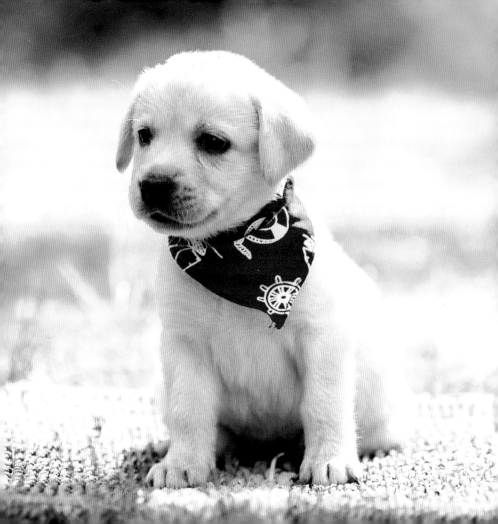

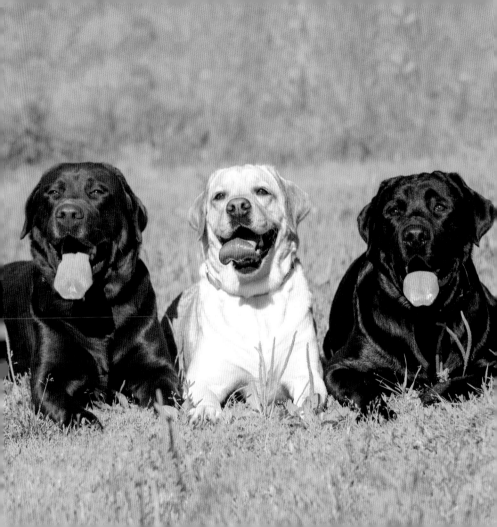

WHY, THANK YOU.
I SUPPOSE WE
♥ ARE RATHER ♥
FETCHING

EVERYTHING I KNOW,
I LEARNED FROM DOGS.

Nora Roberts

♥ DON'T STOP ♥ RETRIEVING!

SCRATCH A DOG AND YOU'LL FIND A PERMANENT JOB.

Franklin P. Jones

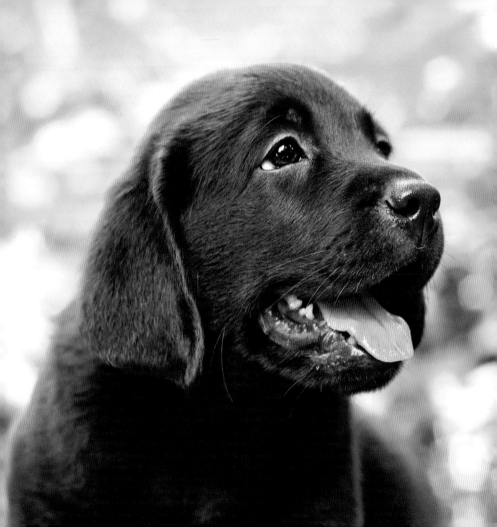

I LOVE YOU
MORE THAN
ANYTHING...
♥ EXCEPT MY ♥

LABRADOR

A DOG IS THE ONLY THING ON EARTH THAT LOVES YOU MORE THAN HE LOVES HIMSELF.

Josh Billings

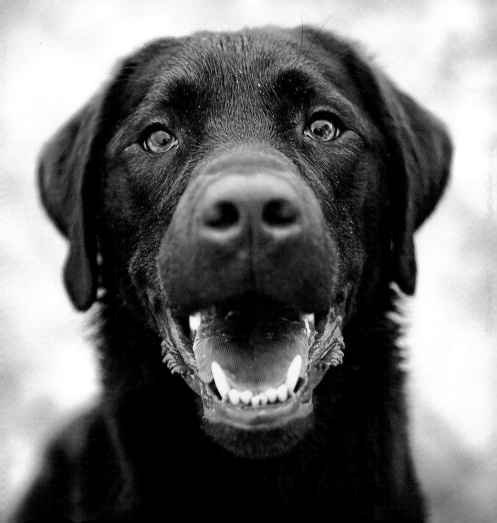

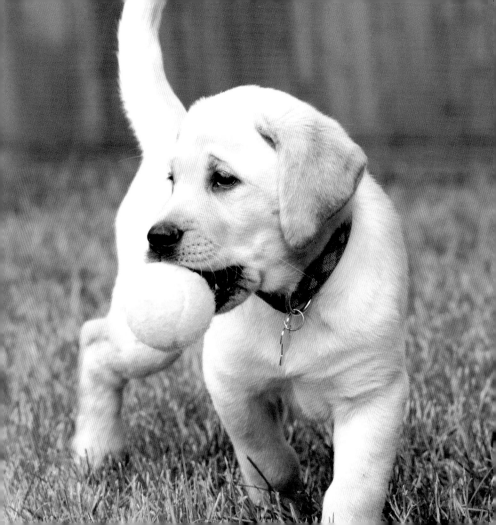

IF YOU WANT THE
BALL SO MUCH,
WHY DO YOU KEEP
THROWING IT?

DOGS ARE MIRACLES WITH PAWS.

Susan Ariel Rainbow Kennedy

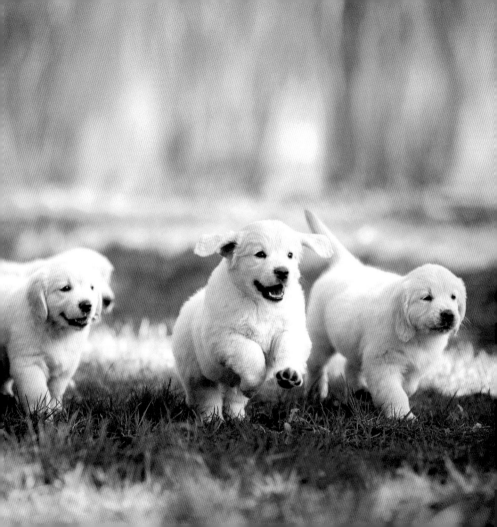

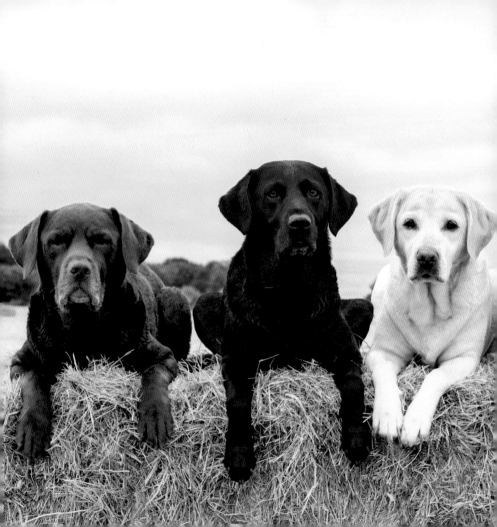

#SQUAD GOALS

NO ONE APPRECIATES THE VERY SPECIAL GENIUS OF YOUR CONVERSATION AS THE DOG DOES.

Christopher Morley

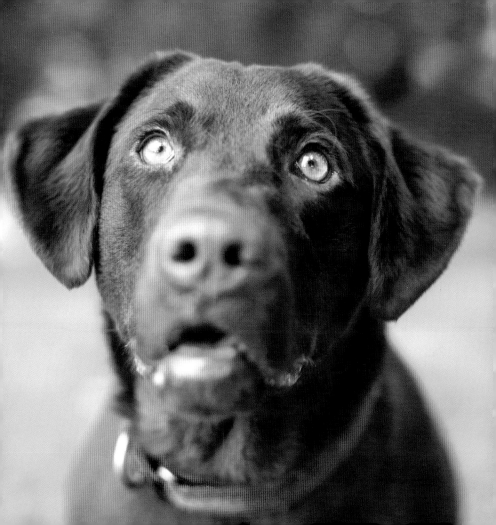

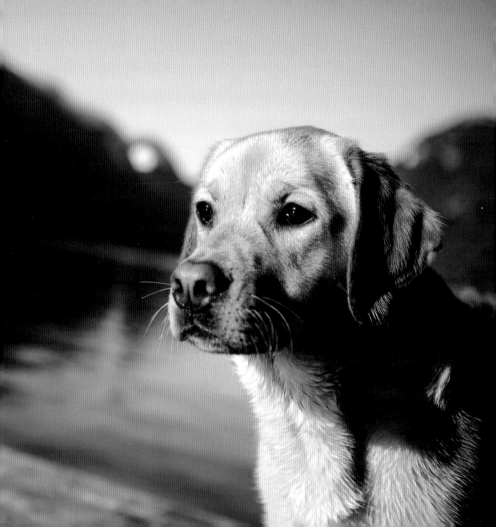

EVERY DAY

♥ IS A NEW ♥

ADVENTURE

FROM THE DOG'S POINT OF VIEW,
HIS MASTER IS AN ELONGATED AND
ABNORMALLY CUNNING DOG.

Mabel Louise Robinson

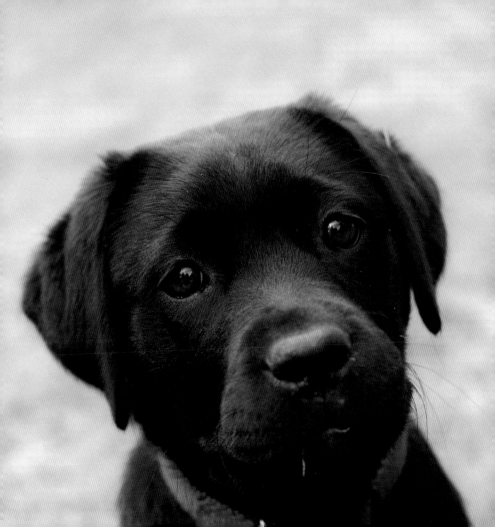

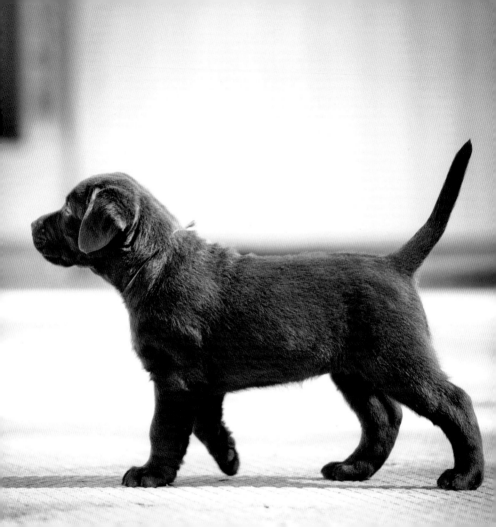

FEARLESS,
FAITHFUL
AND JUST A
♥ LITTLE BIT ♥

FLUFFY

A WELL-TRAINED DOG WILL MAKE
NO ATTEMPT TO SHARE YOUR LUNCH.
HE WILL JUST MAKE YOU FEEL SO GUILTY
THAT YOU CANNOT ENJOY IT.

Helen Thomson

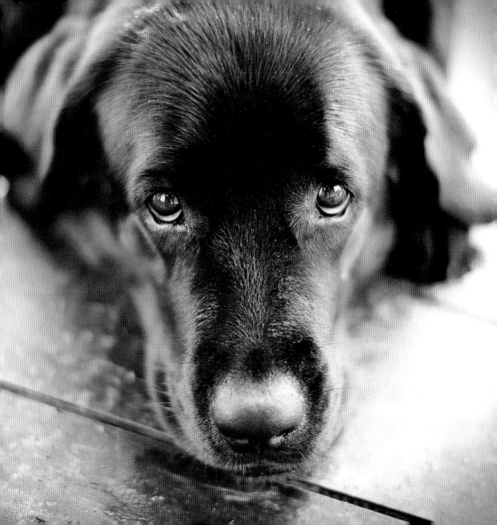

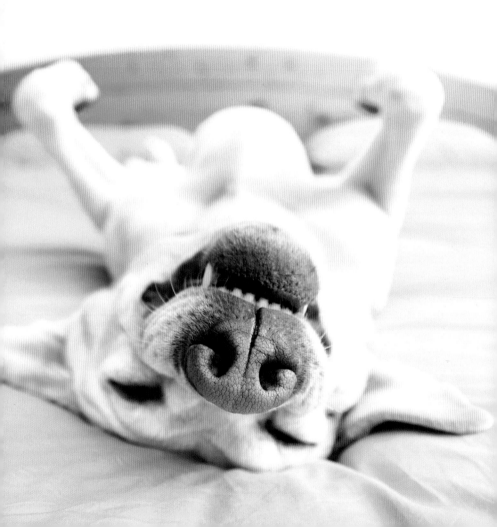

FIRST, I STEAL YOUR HEART, THEN I STEAL YOUR BED

DOGS ARE NOT OUR WHOLE LIFE, BUT THEY MAKE OUR LIVES WHOLE.

Roger Caras

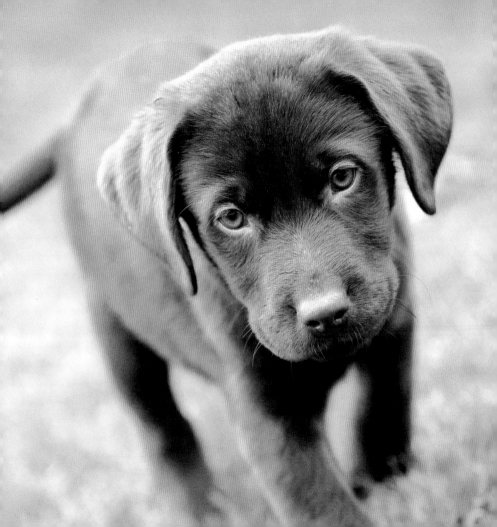

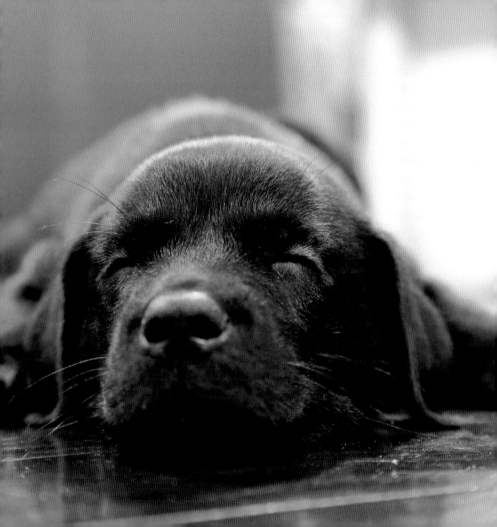

IT'S EXHAUSTING
♥ BEING THIS CUTE ♥

ALL THE TIME!

DOGS FEEL VERY STRONGLY THAT
THEY SHOULD ALWAYS GO WITH YOU
IN THE CAR, IN CASE THE NEED SHOULD
ARISE FOR THEM TO BARK VIOLENTLY
AT NOTHING RIGHT IN YOUR EAR.

Dave Barry

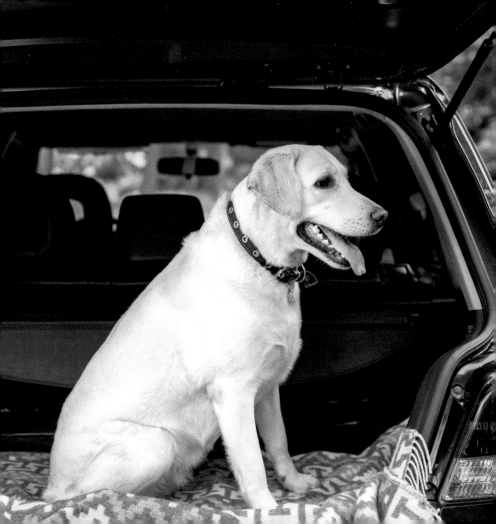

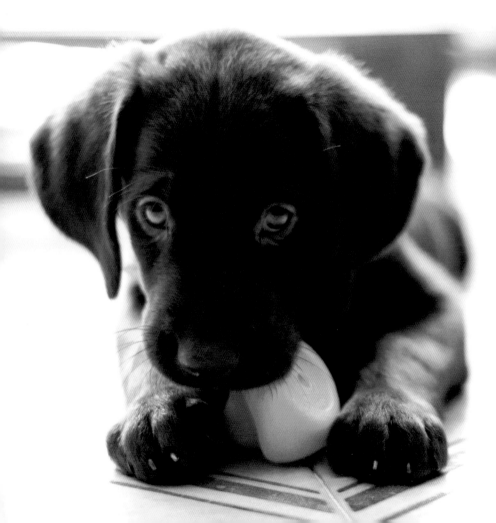

THE JOURNEY OF LIFE
IS SWEETER WHEN
TRAVELLED WITH A
LABRADOR

NO MATTER HOW LITTLE MONEY OR
HOW FEW POSSESSIONS YOU OWN,
HAVING A DOG MAKES YOU RICH.

Louis Sabin

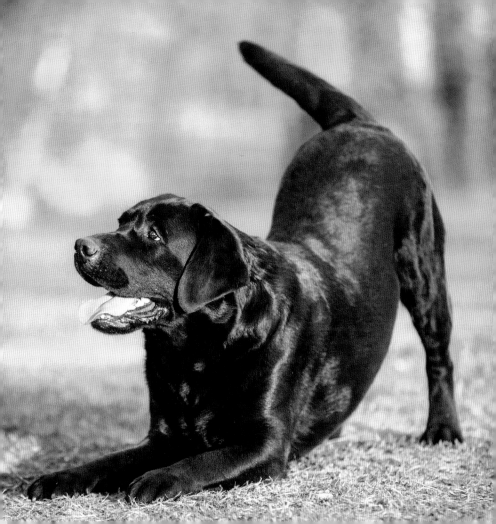

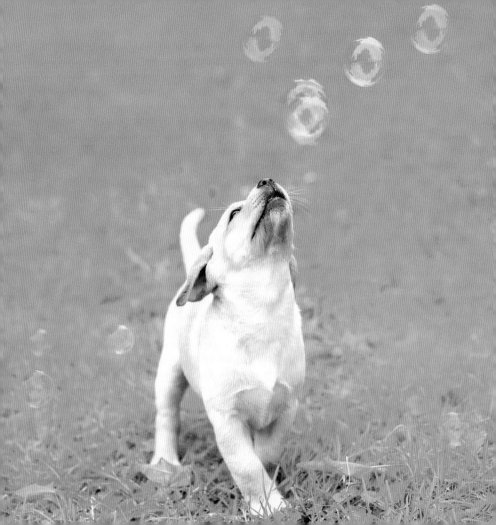

IT'S ALWAYS A GOOD DAY TO BE A ♥ LABRADOR ♥

HAVING A DOG WILL BLESS YOU WITH MANY OF THE HAPPIEST DAYS OF YOUR LIFE.

Anonymous

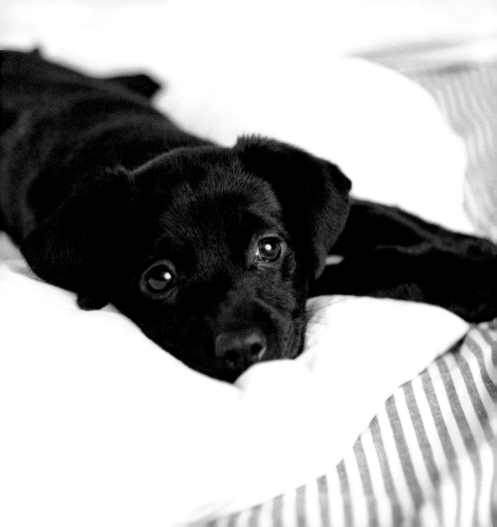

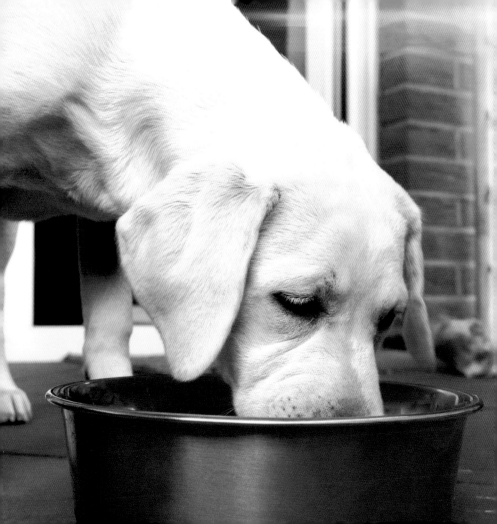

ALL FOOD MUST
♥ BE SENT TO ♥

THE LAB

FOR TESTING!

WHEN I NEEDED A HAND, I FOUND YOUR PAW.

Anonymous

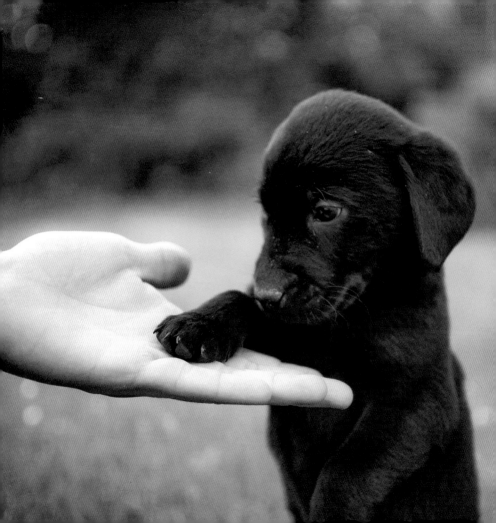

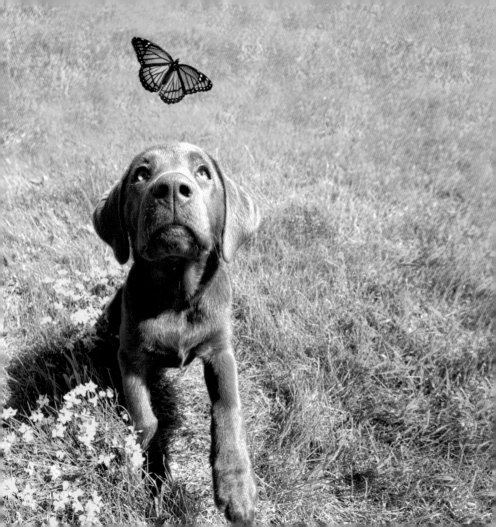

♥ WHAT KIND OF ♥
STRANGE AND ELUSIVE
BALL IS THIS?

DOGS LAUGH, BUT THEY LAUGH WITH THEIR TAILS.

Max Eastman

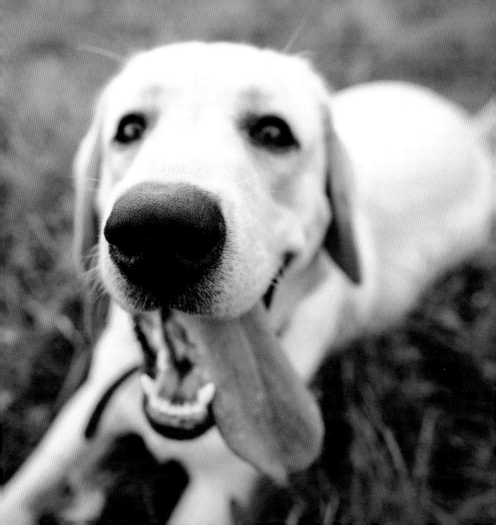

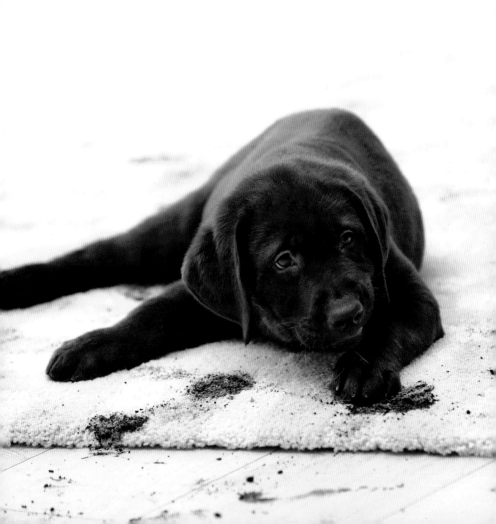

HANG ON, WHAT WAS
♥ THAT YOU SAID ABOUT ♥

WIPING MY PAWS

BEFORE I CAME INSIDE?

THERE IS NO PSYCHIATRIST IN THE WORLD LIKE A PUPPY LICKING YOUR FACE.

Bernard Williams

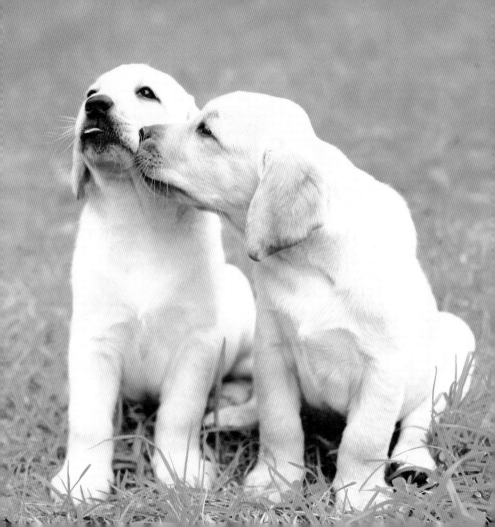

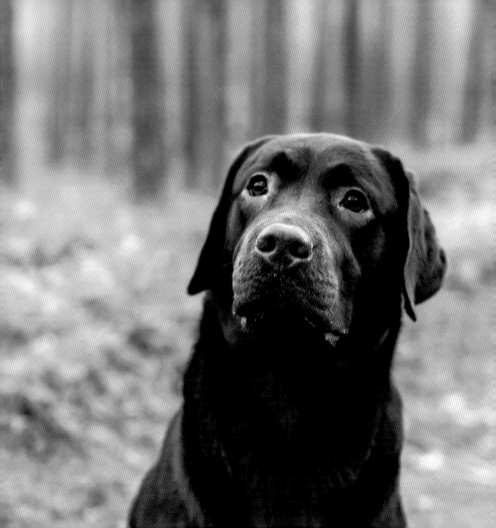

YOU KNOW,
THAT BALL
♥ ISN'T GOING TO ♥
THROW ITSELF!

THE DOG WAS CREATED SPECIALLY FOR CHILDREN. HE IS THE GOD OF FROLIC.

Henry Ward Beecher

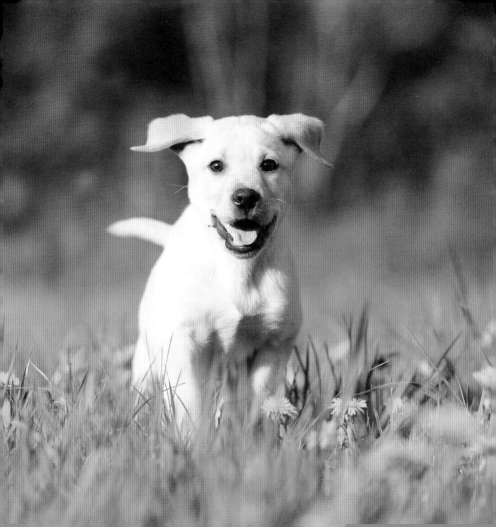

I DARE YOU

♥ NOT TO ♥

LABR-ADORE ME!

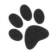

THE AVERAGE DOG IS NICER THAN THE AVERAGE PERSON.

Andy Rooney

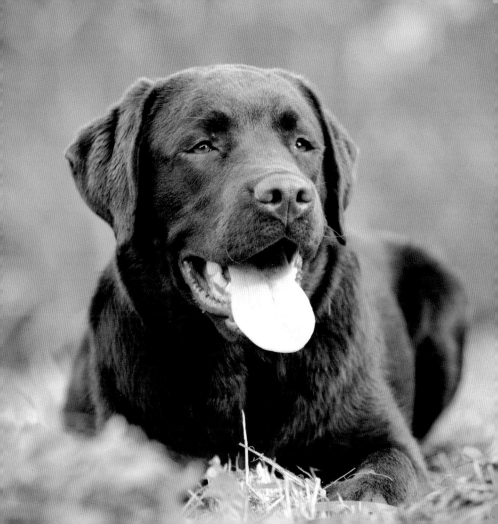

IT'S DEFINITELY A

DUVET DAY

WHY DOES WATCHING A DOG BE A DOG FILL ONE WITH HAPPINESS?

Jonathan Safran Foer

UH-OH, I THINK
THEY'VE FOUND
♥ THE EMPTY ♥
TREAT BAGS!

A DOG IS A BUNDLE OF PURE LOVE, GIFT-WRAPPED IN FUR.

Andrea Lochen

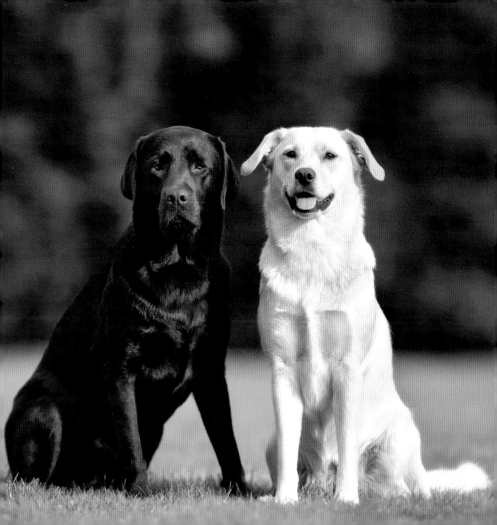

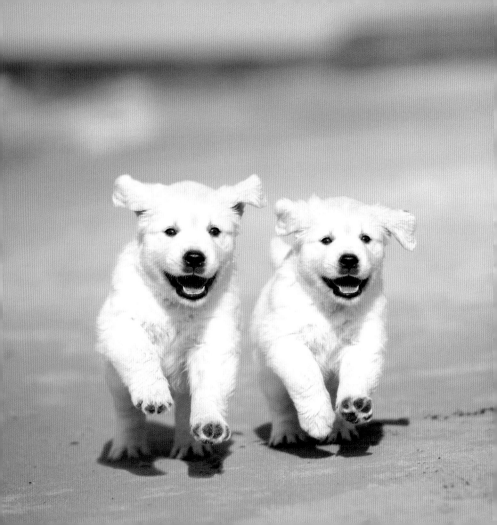

HAPPINESS?

WE CAN RETRIEVE
♥ THAT FOR YOU! ♥

THE GREAT PLEASURE OF A DOG IS THAT
YOU MAY MAKE A FOOL OF YOURSELF WITH
HIM AND NOT ONLY WILL HE NOT SCOLD YOU,
BUT HE WILL MAKE A FOOL OF HIMSELF TOO.

Samuel Butler

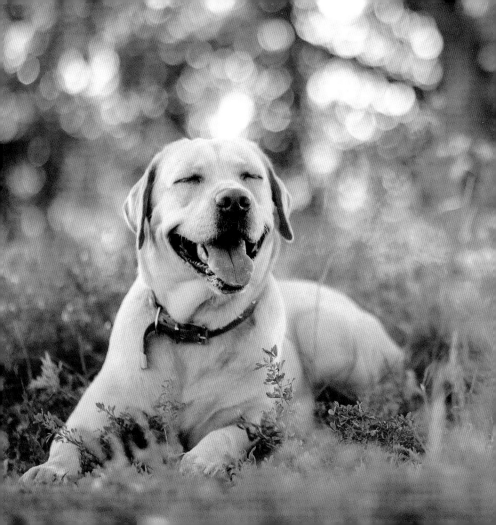

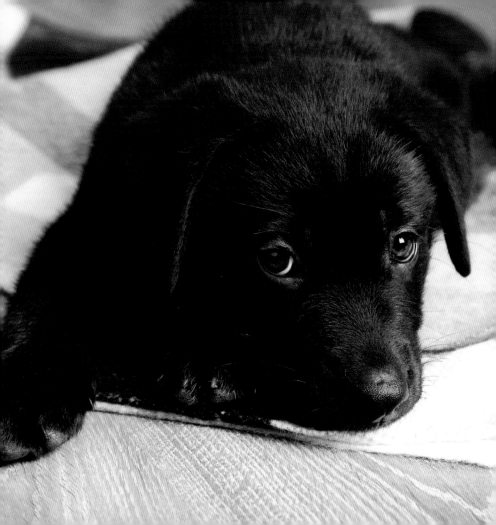

HOME

IS WHERE YOUR

♥ LABRADOR IS ♥

WHAT DO DOGS DO ON THEIR DAY OFF? CAN'T LIE AROUND — THAT'S THEIR JOB!

George Carlin

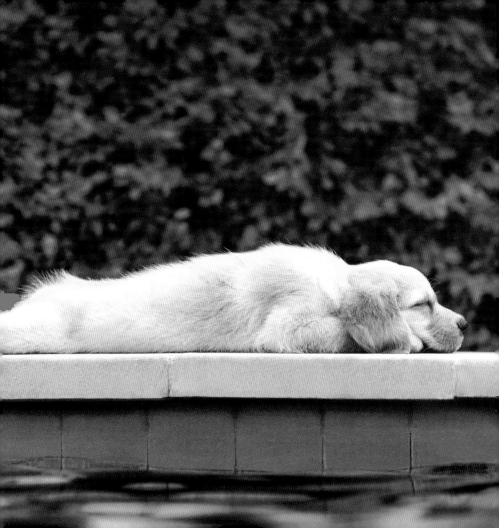

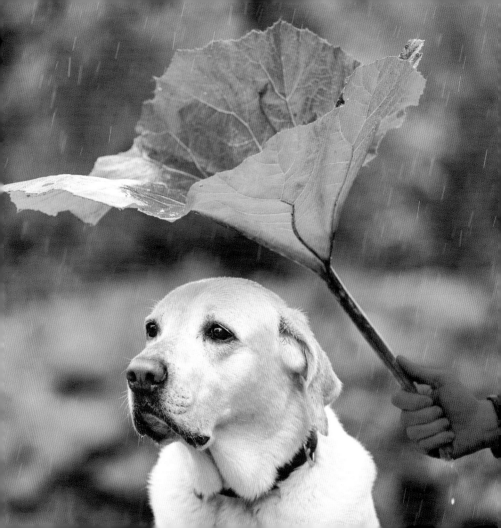

♥ IT NEVER RAINS ♥

BUT IT PAWS

THE DOG LIVES FOR THE DAY, THE HOUR, EVEN THE MOMENT.

Robert Falcon Scott

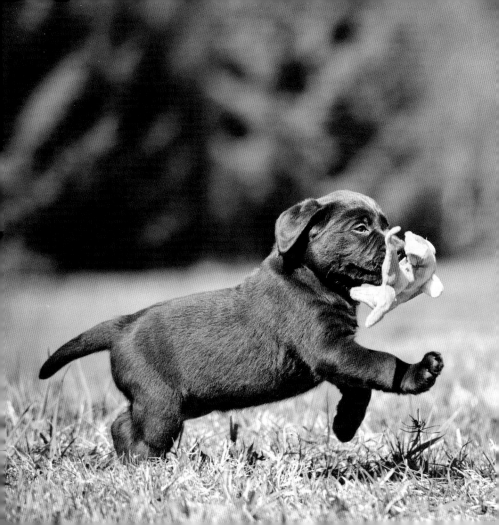

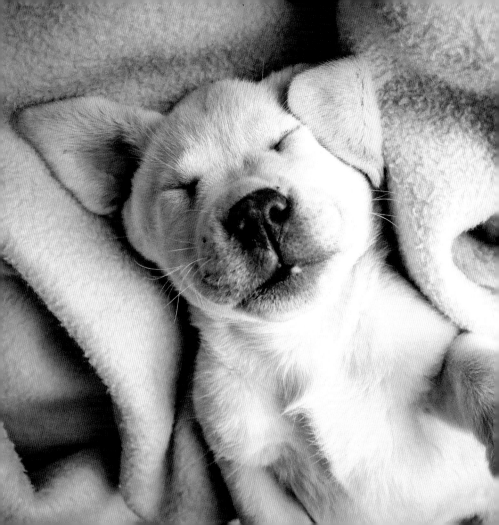

YOU DON'T GET
THIS CUTE
♥ WITHOUT YOUR ♥
BEAUTY SLEEP!

THE WORLD WOULD BE A NICER PLACE
IF EVERYONE HAD THE ABILITY TO LOVE
AS UNCONDITIONALLY AS A DOG.

M. K. Clinton

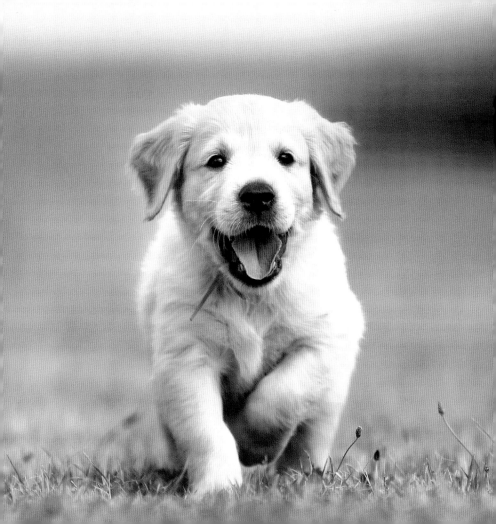

If you're interested in finding out more about our books, find us on Facebook at **Summersdale Publishers** and follow us on Twitter at **@Summersdale**.

www.summersdale.com

IMAGE CREDITS